This Pilgrim's Progress coloring book belongs to:

☐ ☐ ☐ ☐ ☐ ☐ ☐ ☐ ☐ ☐ ☐ ☐ ☐ ☐ ☐

Copyright 2019 Arianna Francis Art

www.ariannafrancisart.com

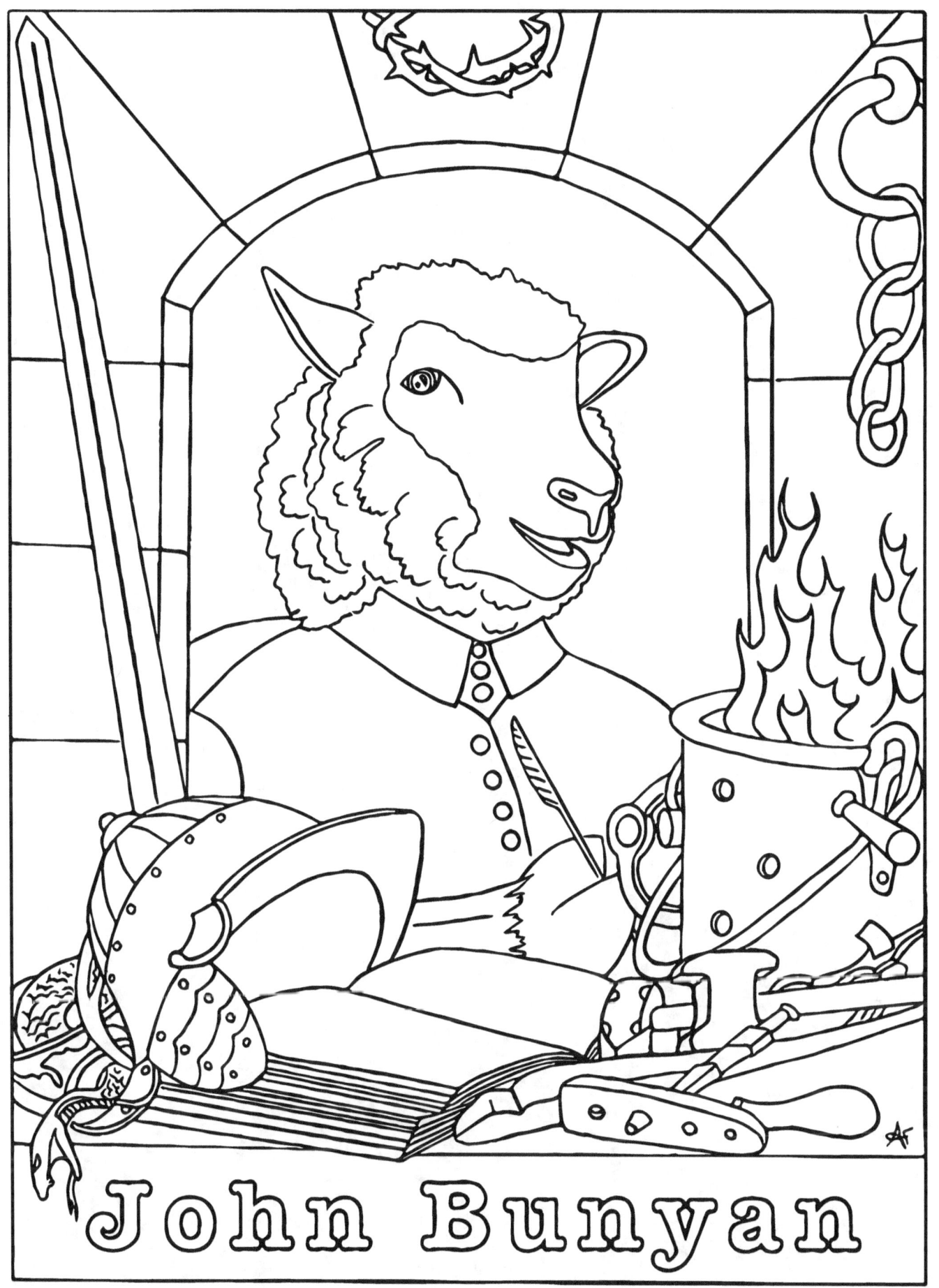

John Bunyan

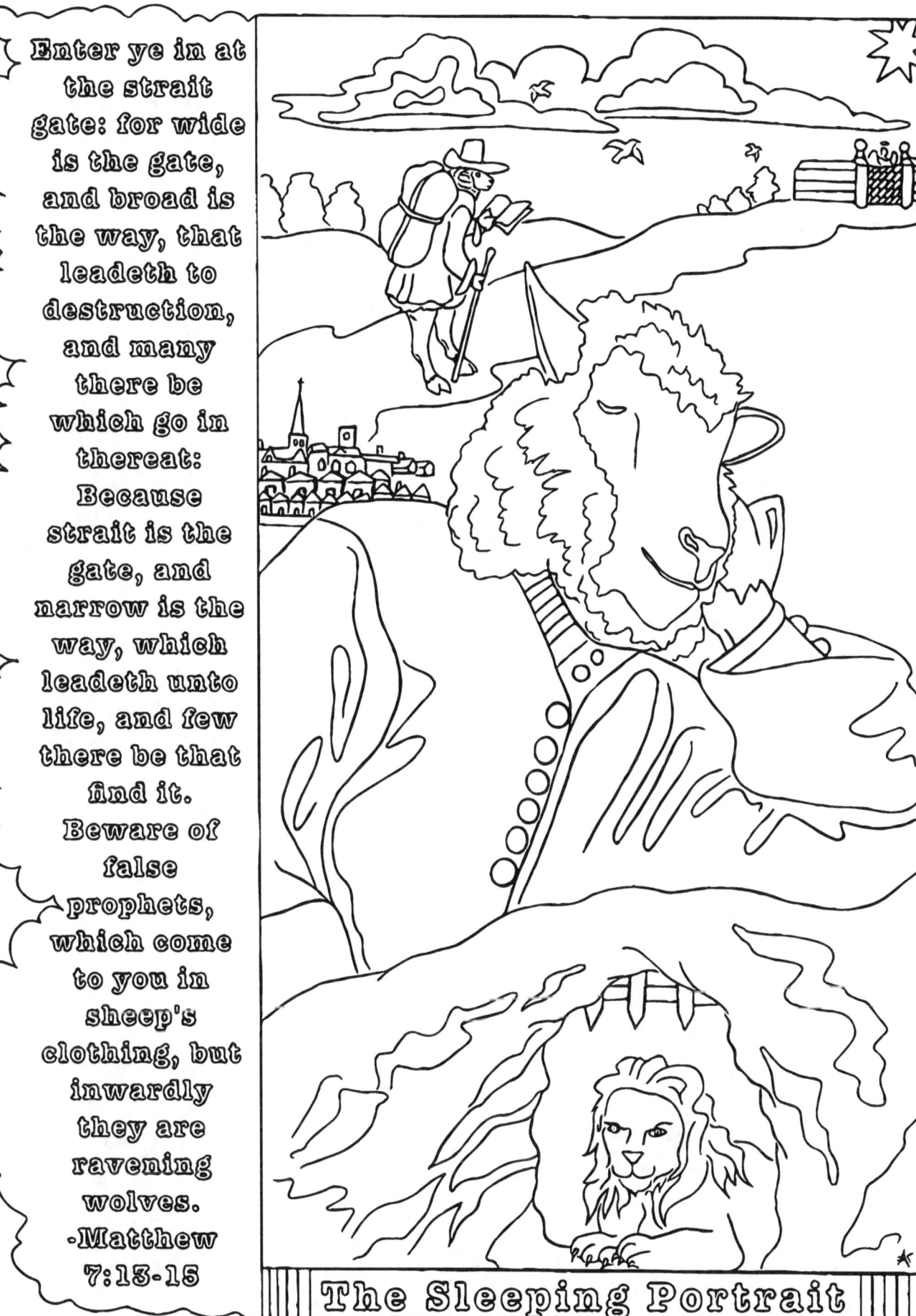

John Bunyan Dreaming

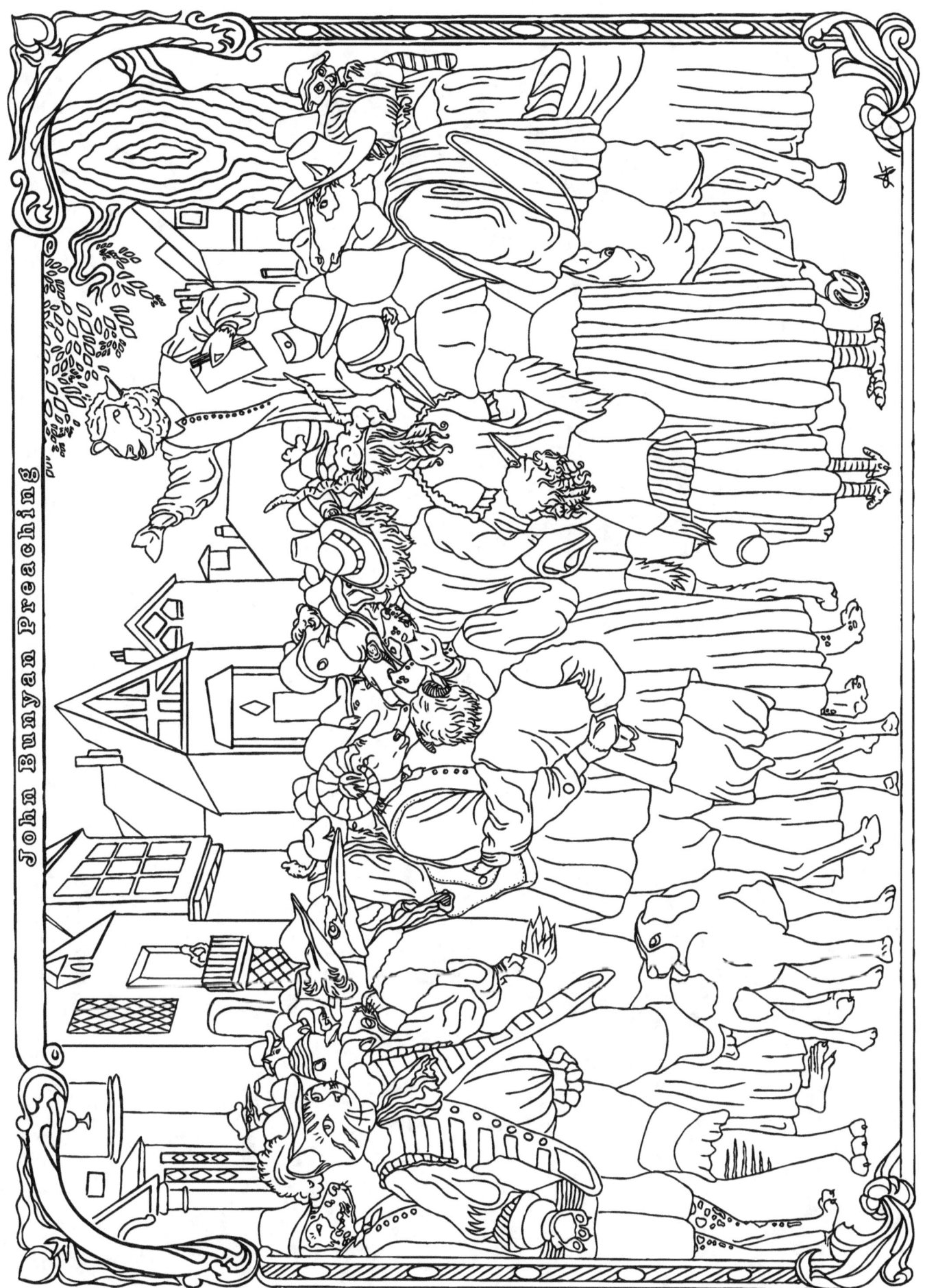

John Bunyan Preaching

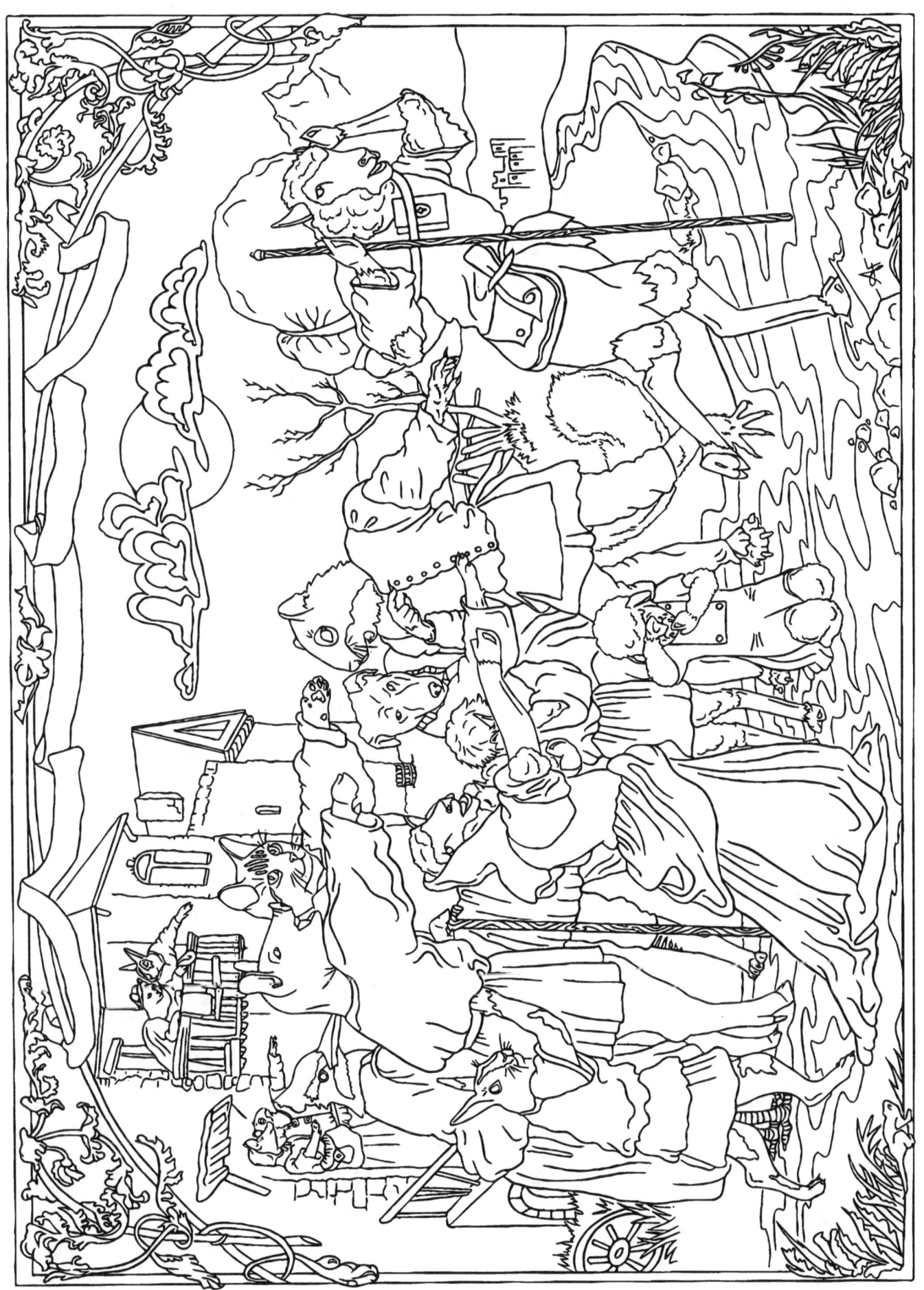

Christian leaves The City of Destruction

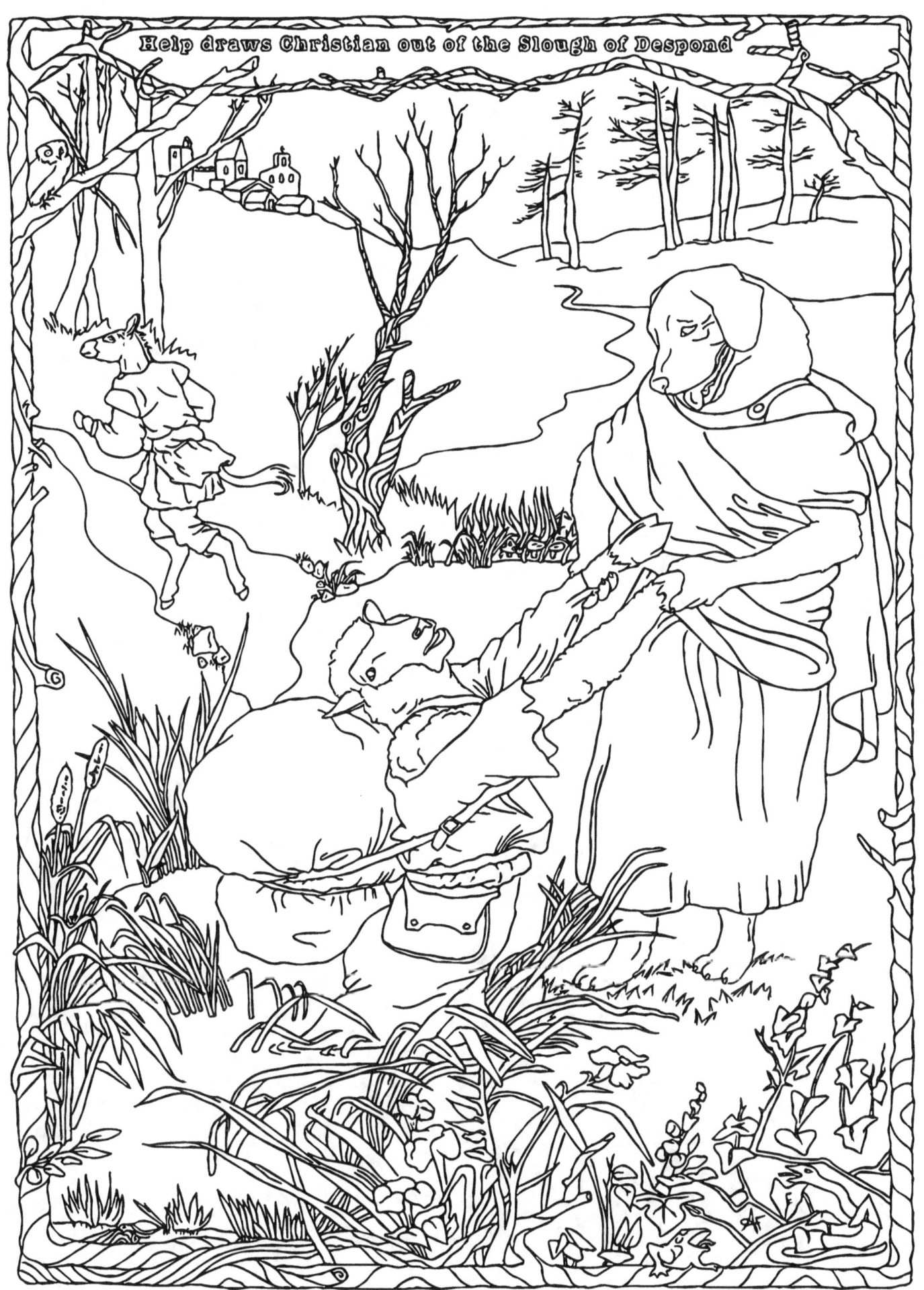

The Slough of Despond

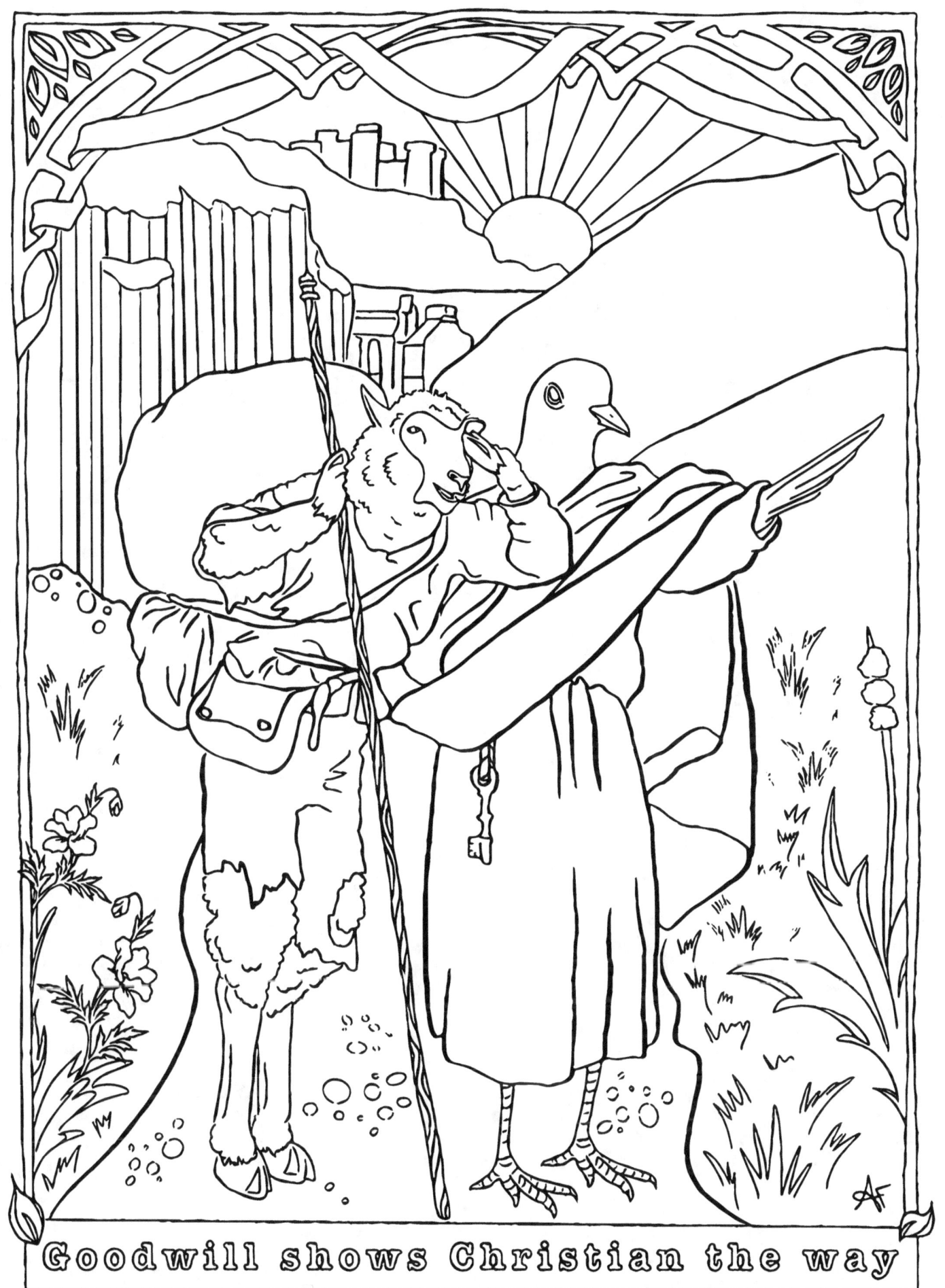

Goodwill shows Christian the way

Goodwill shows Christian the way

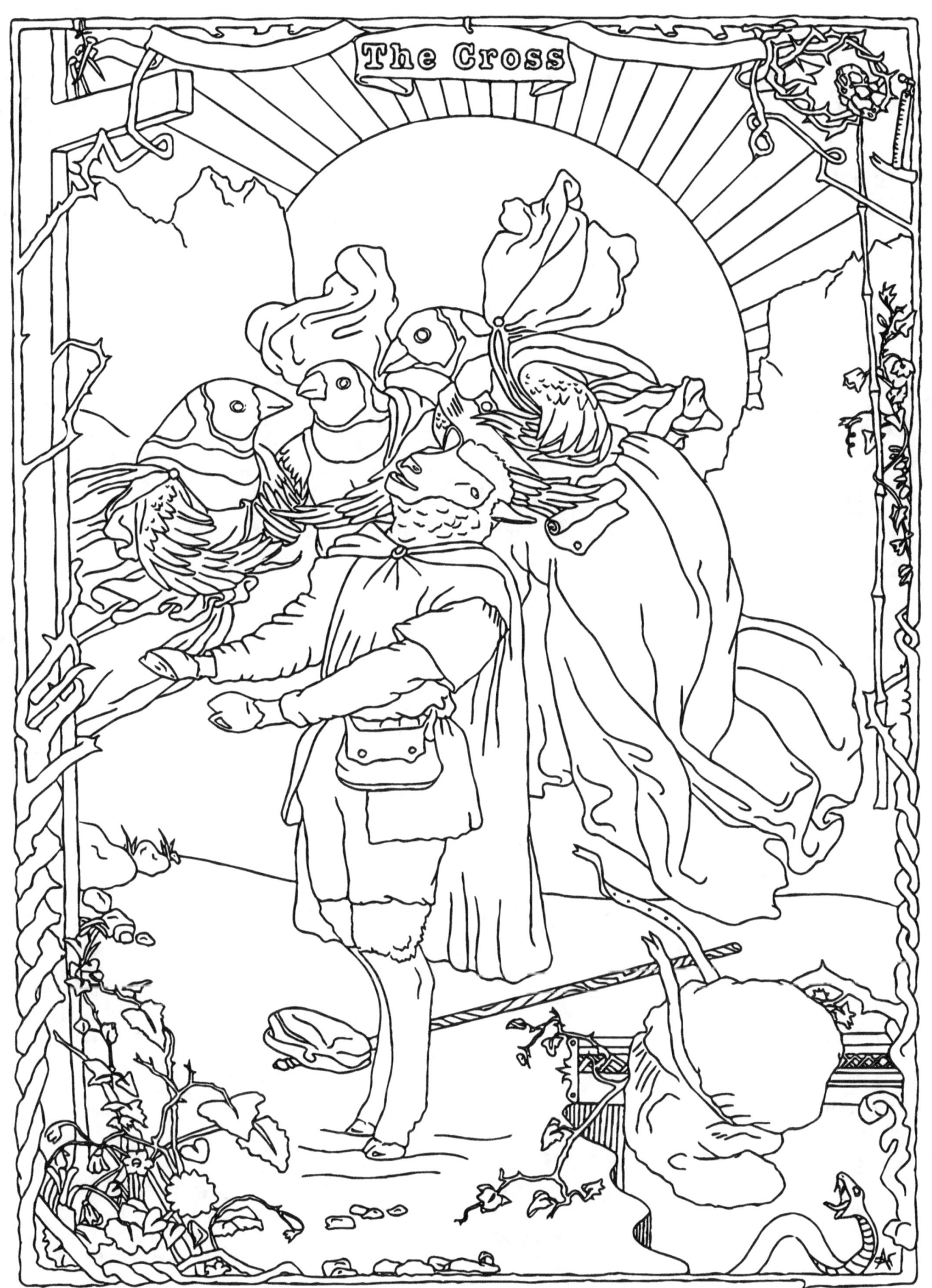

In view of the cross

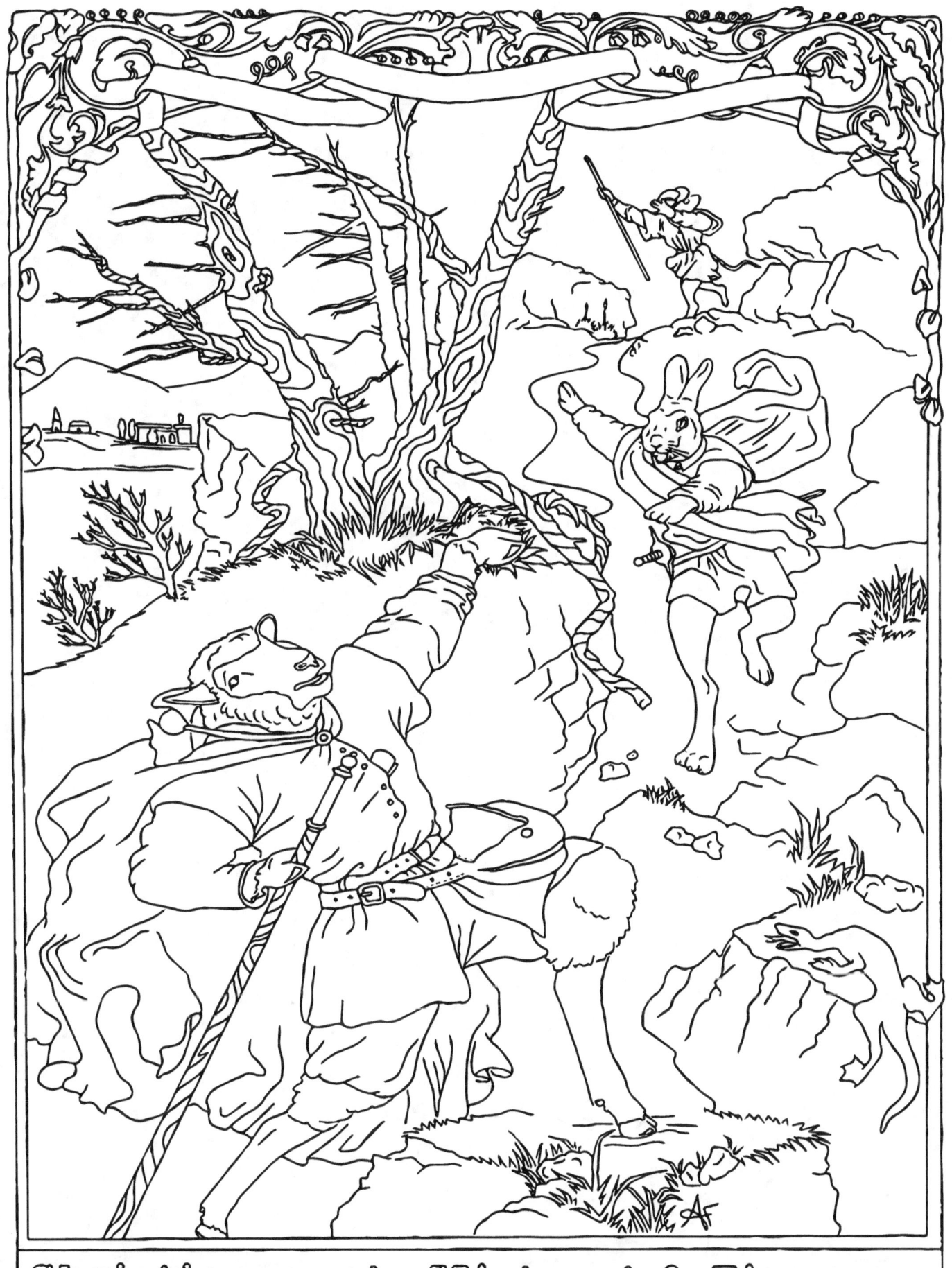

Christian meets Mistrust & Timorous

Christian meets Mistrust and Timorous

Watchful

Notwithstanding the Lord stood with me, and strengthened me; that by me the preaching might be fully known, and that all the Gentiles might hear: and I was delivered out of the mouth of the lion. And the Lord shall deliver me from every evil work, and will preserve me unto his heavenly kingdom: to whom be glory for ever and ever. Amen.

-2 Timothy 4:17-18

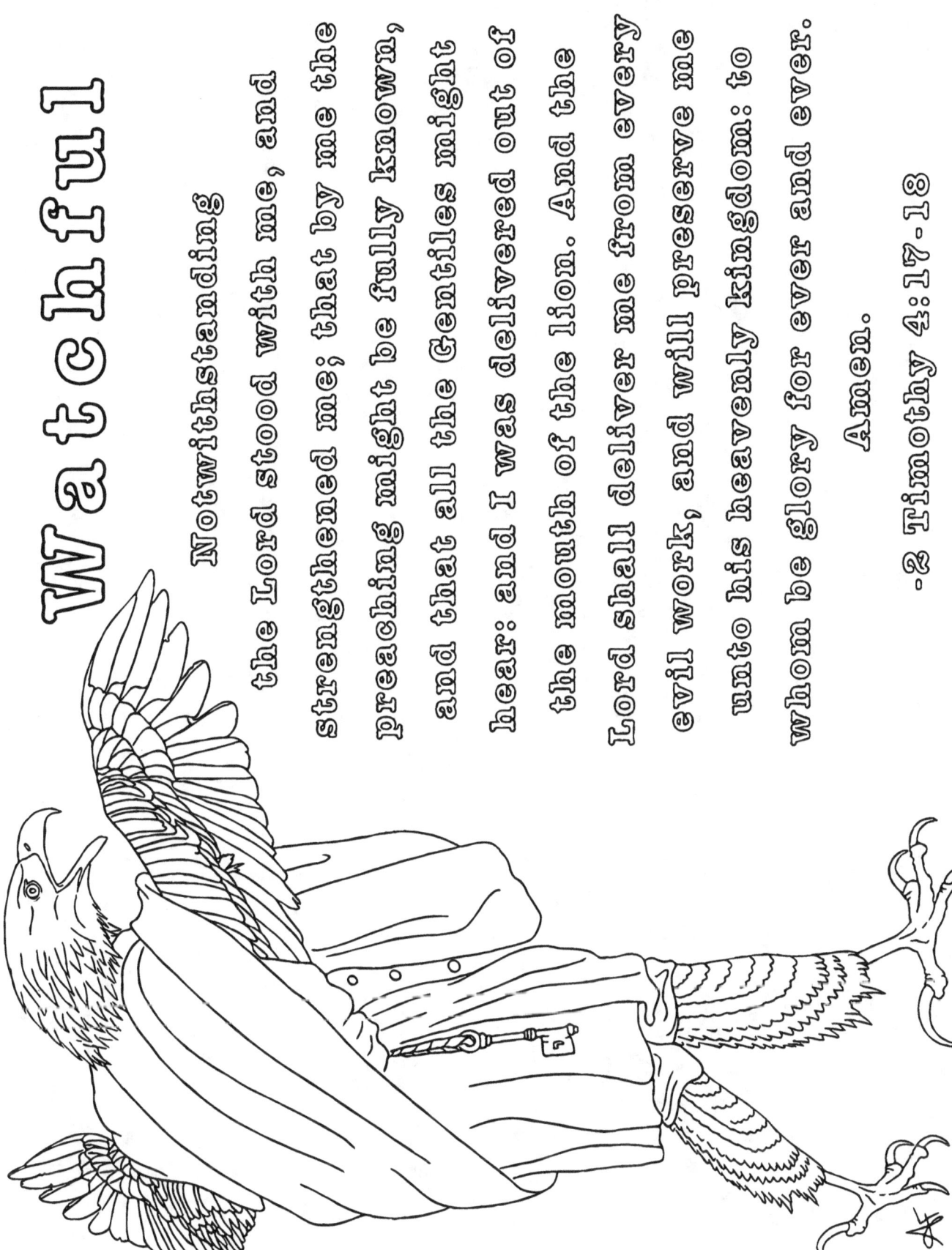

Watchful

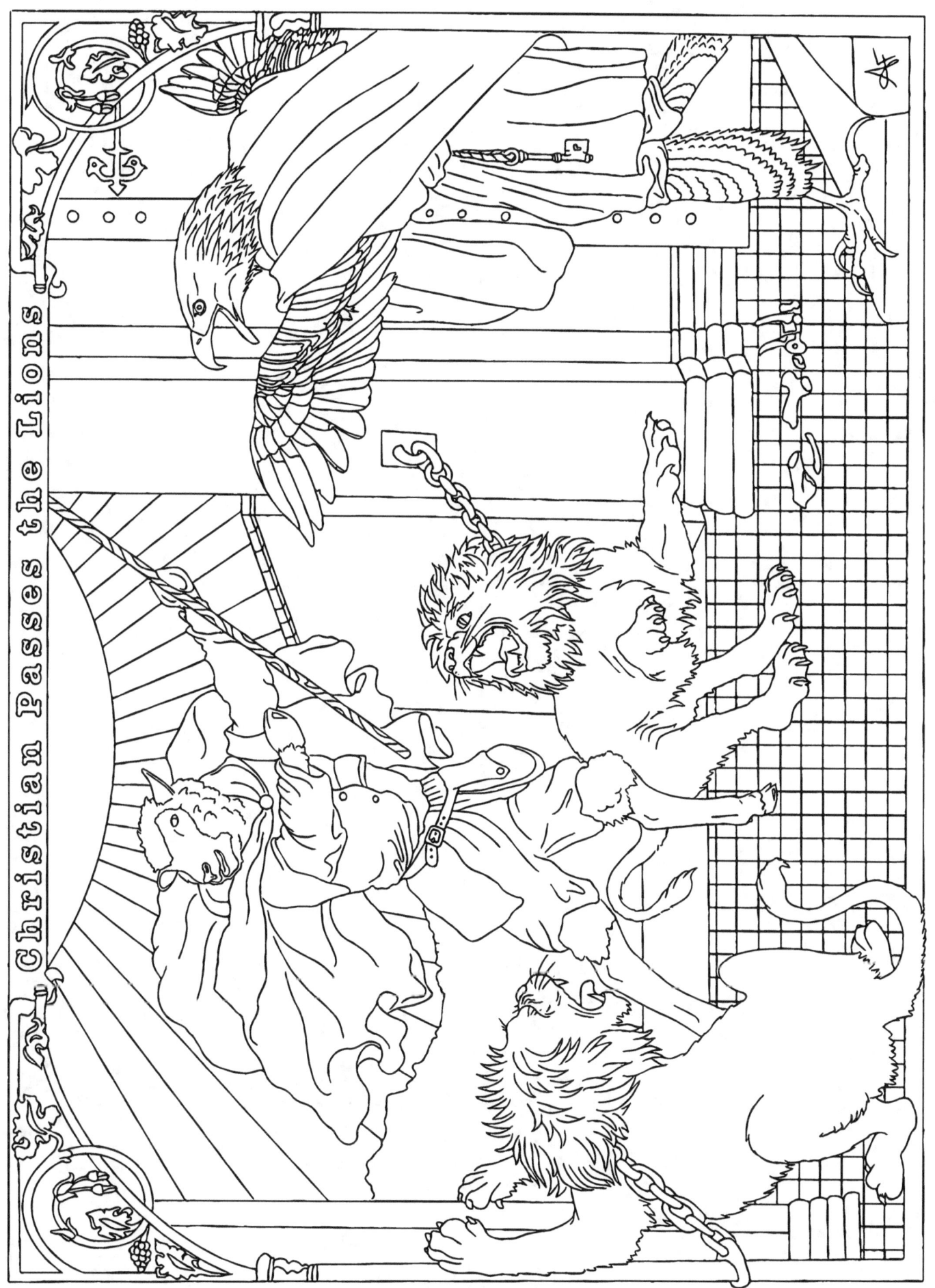

Passing the Lions

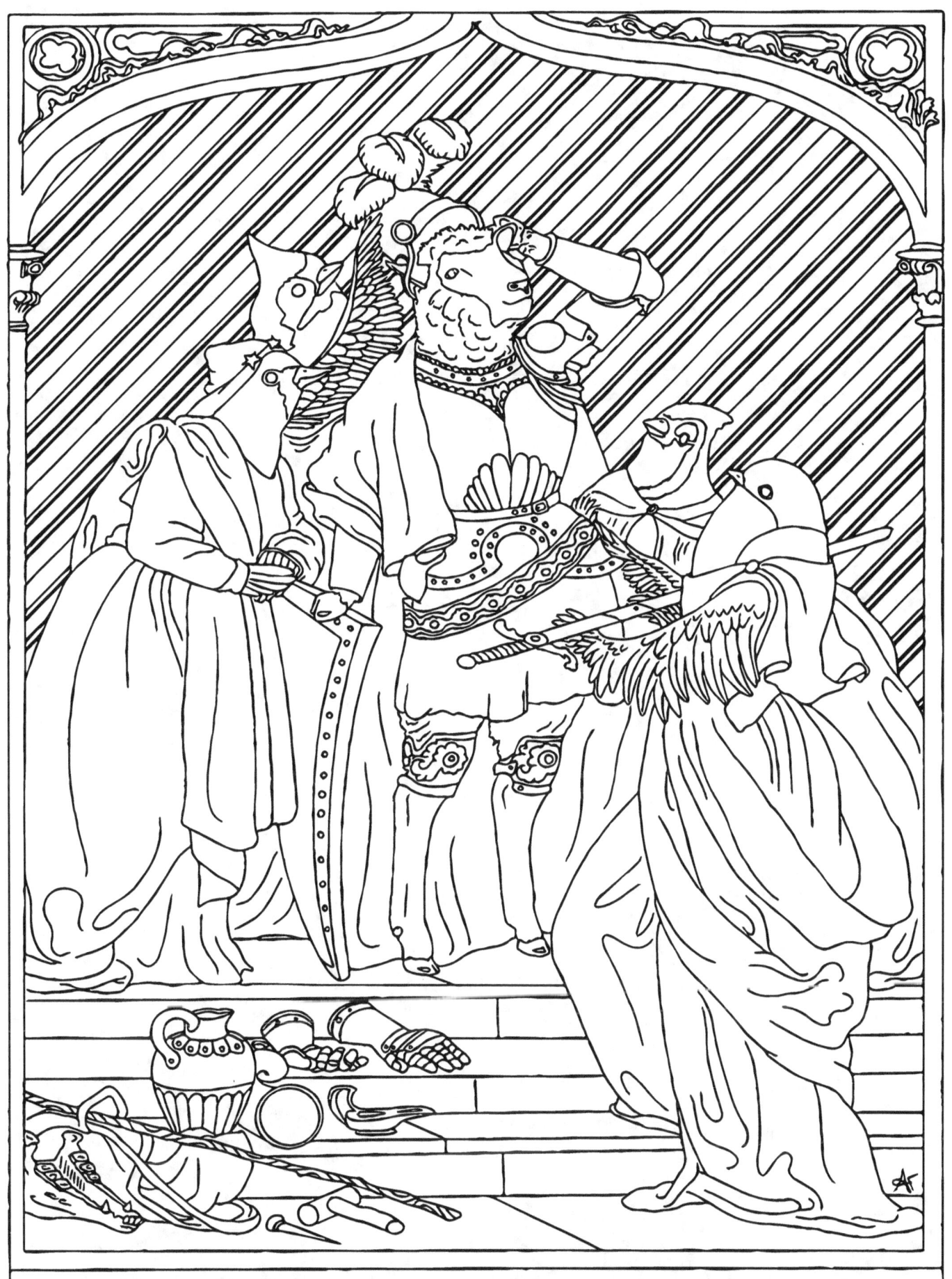
Christian armed by Prudence, Discretion, Piety & Charity

Christian at the Palace

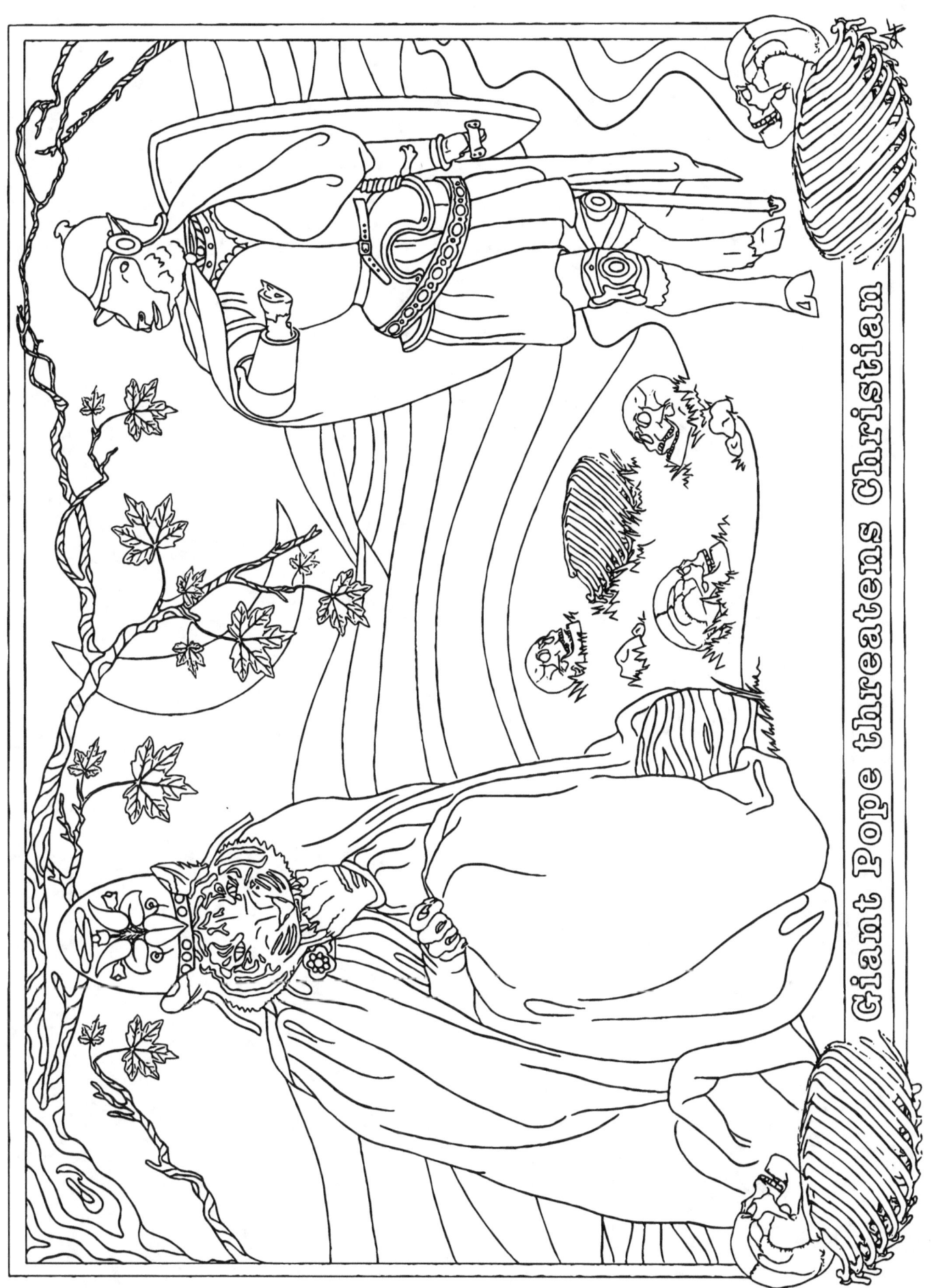

Giant Pope threatens Christian

Giant Pope

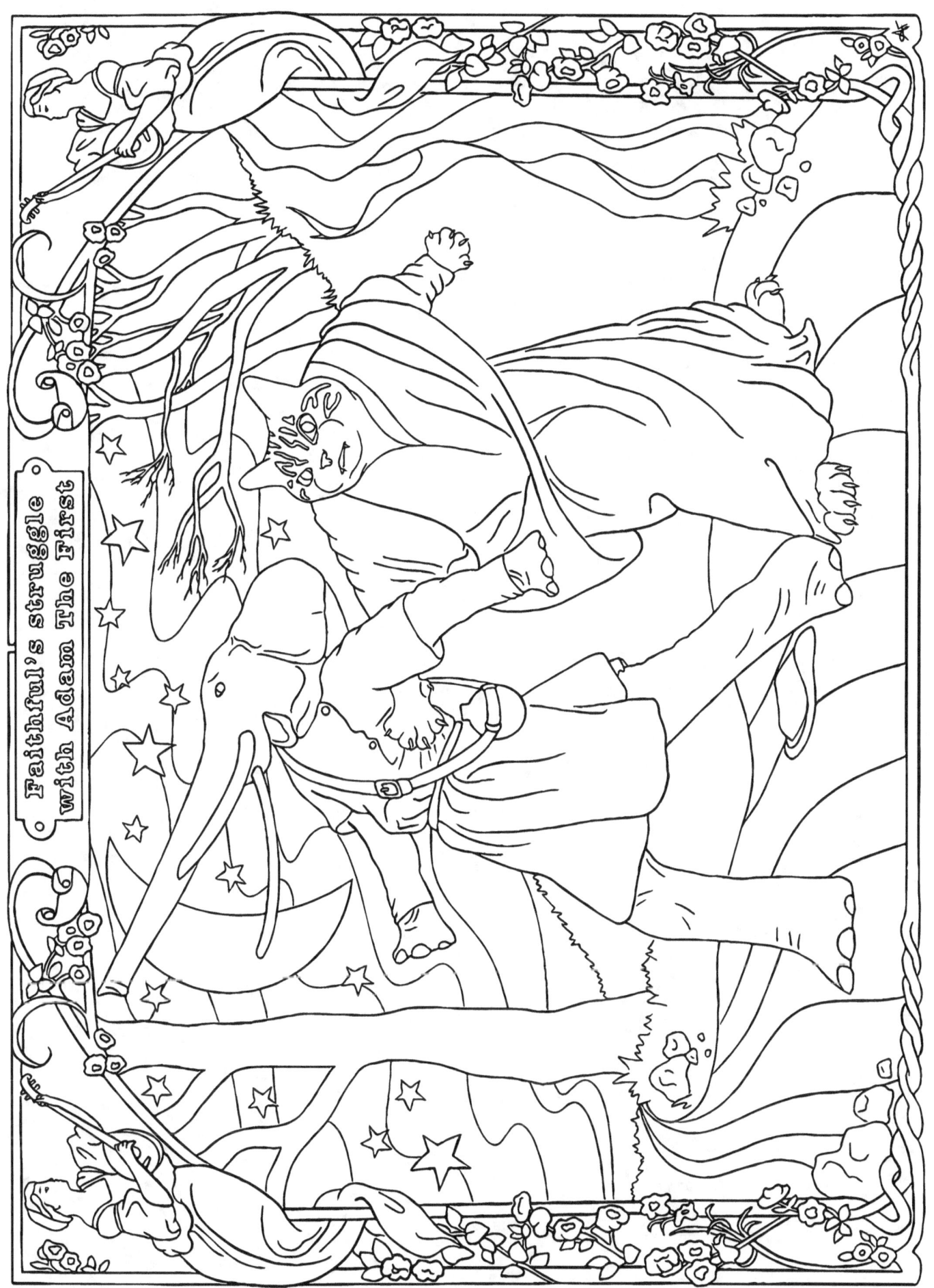

Faithful's Struggle

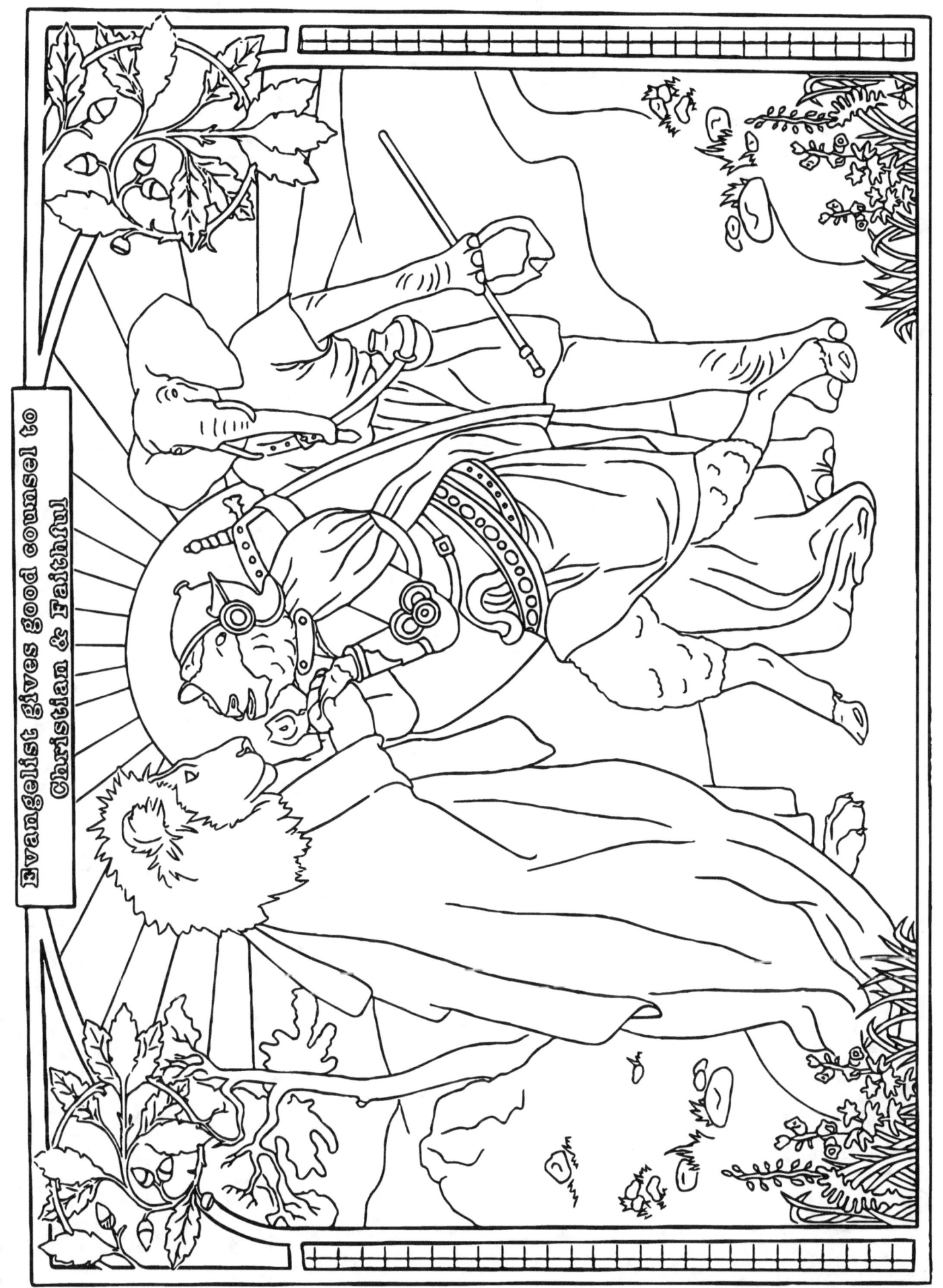

Evangelist Councils

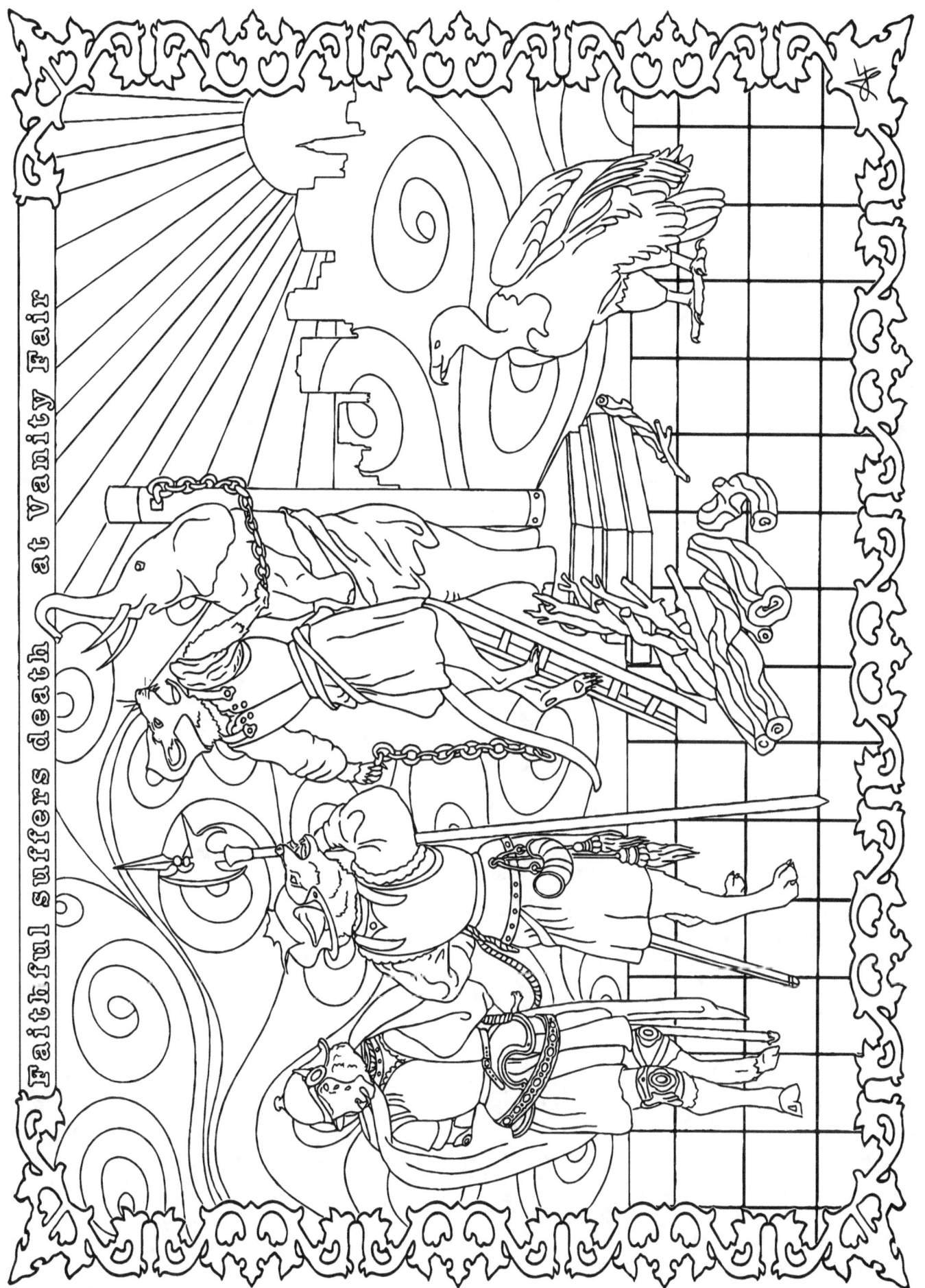

Death at Vanity Fair

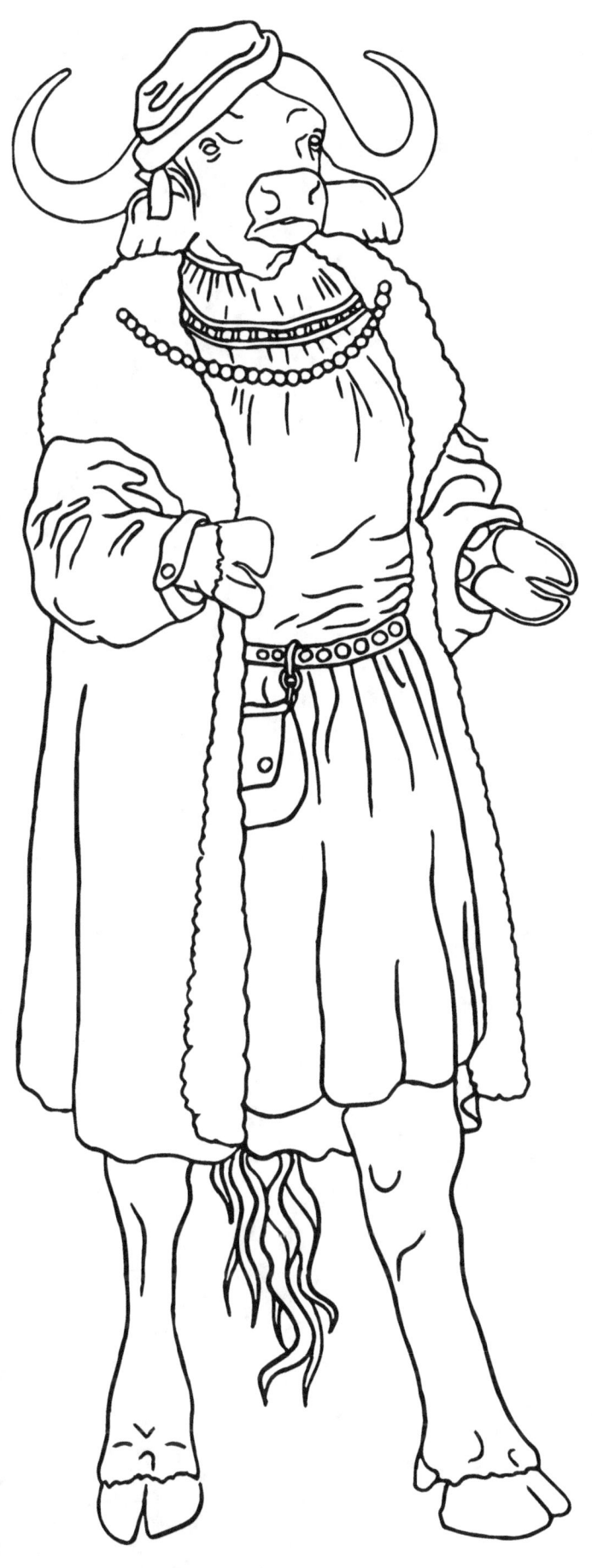

Mr. By-ends

He that walketh righteously, and speaketh uprightly; he that despiseth the gain of oppressions, that shaketh his hands from holding of bribes, that stoppeth his ears from hearing of blood, and shutteth his eyes from seeing evil; He shall dwell on high: his place of defence shall be the munitions of rocks: bread shall be given him; his waters shall be sure. Thine eyes shall see the king in his beauty: they shall behold the land that is very far off.
-Isaiah 33:15-17

Mr. By-ends

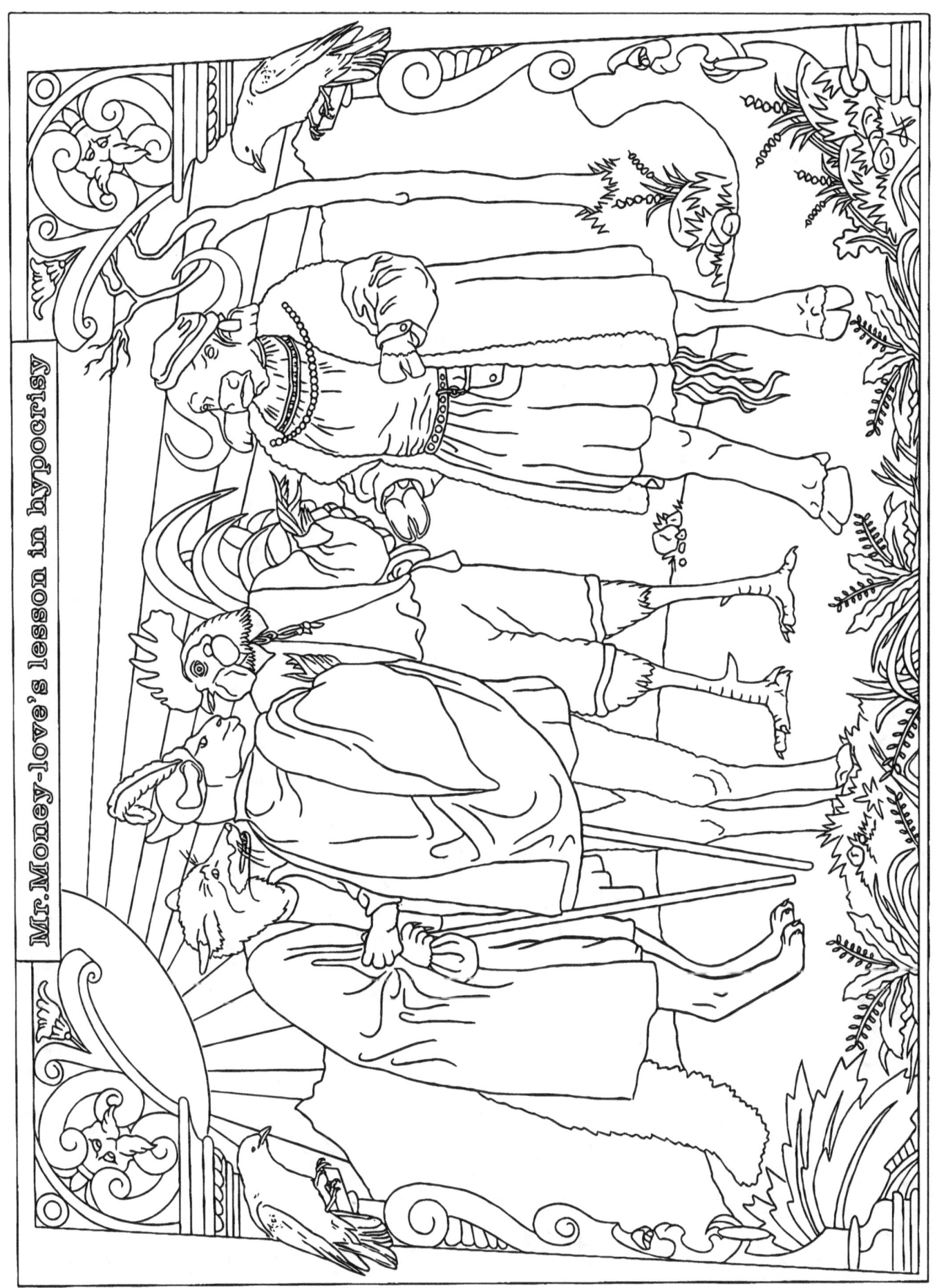

Mr. Money-love's lesson in hypocrisy

Mr. Money-love

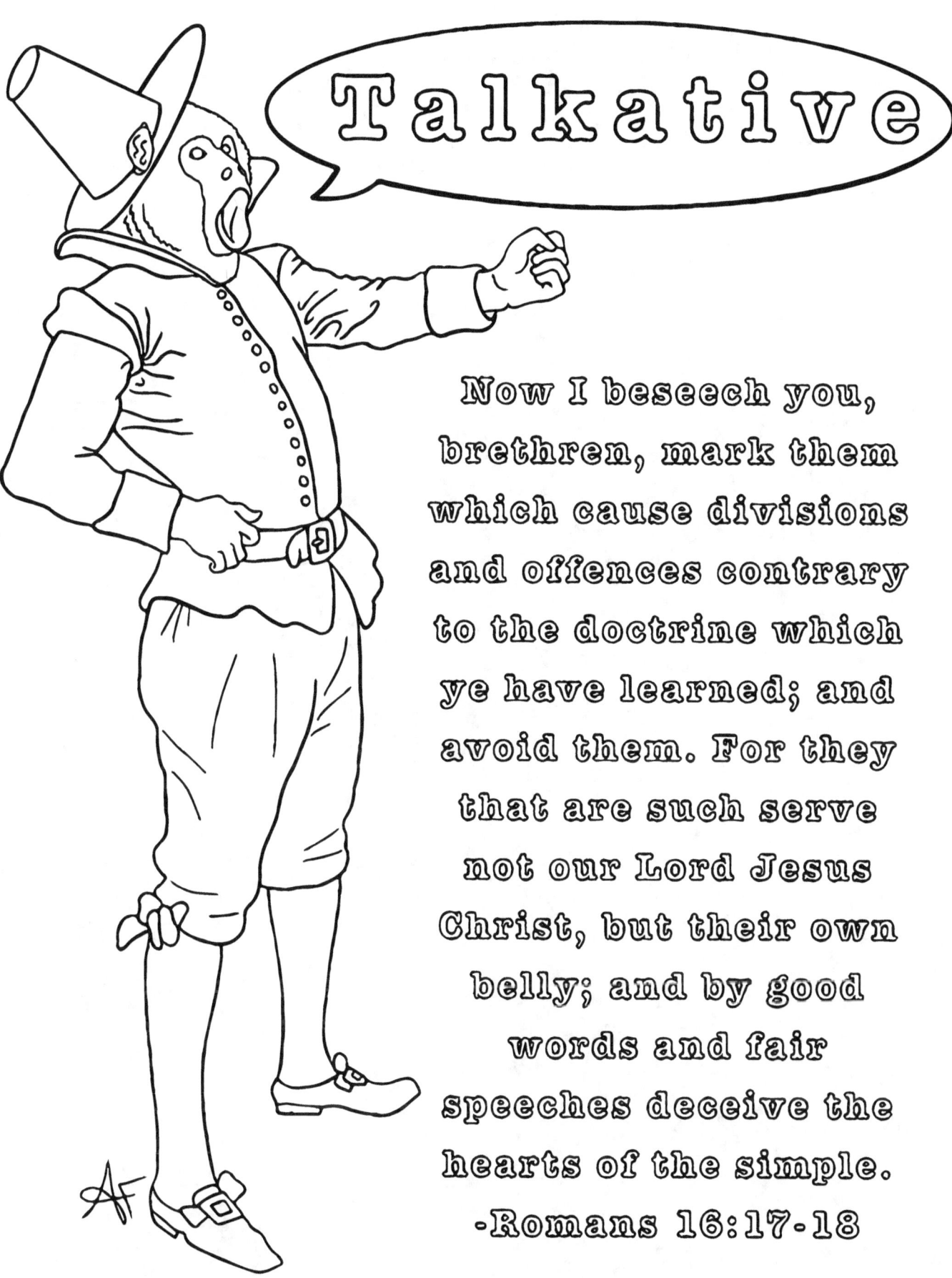

Talkative

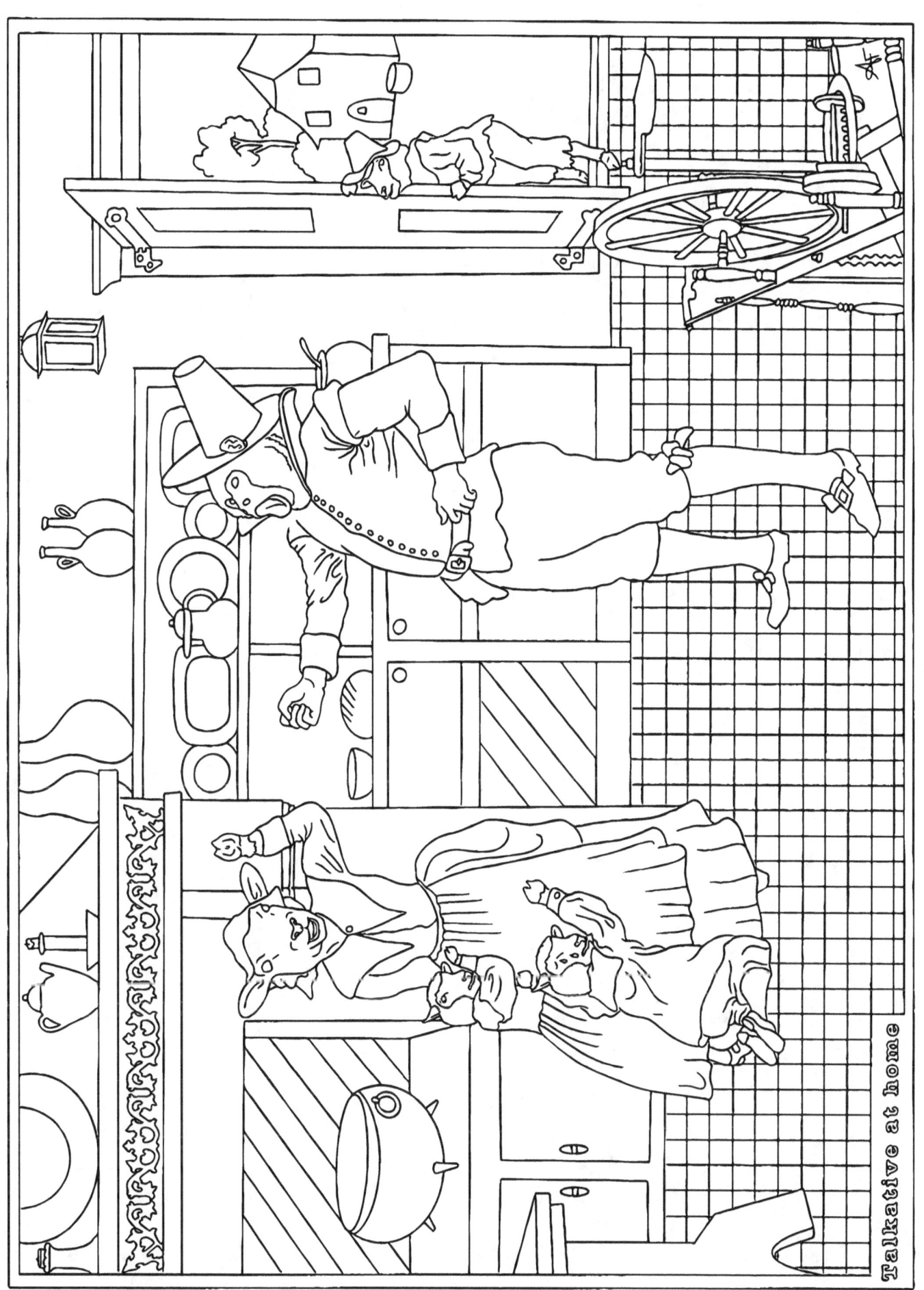

Talkative at home

Talkative at home

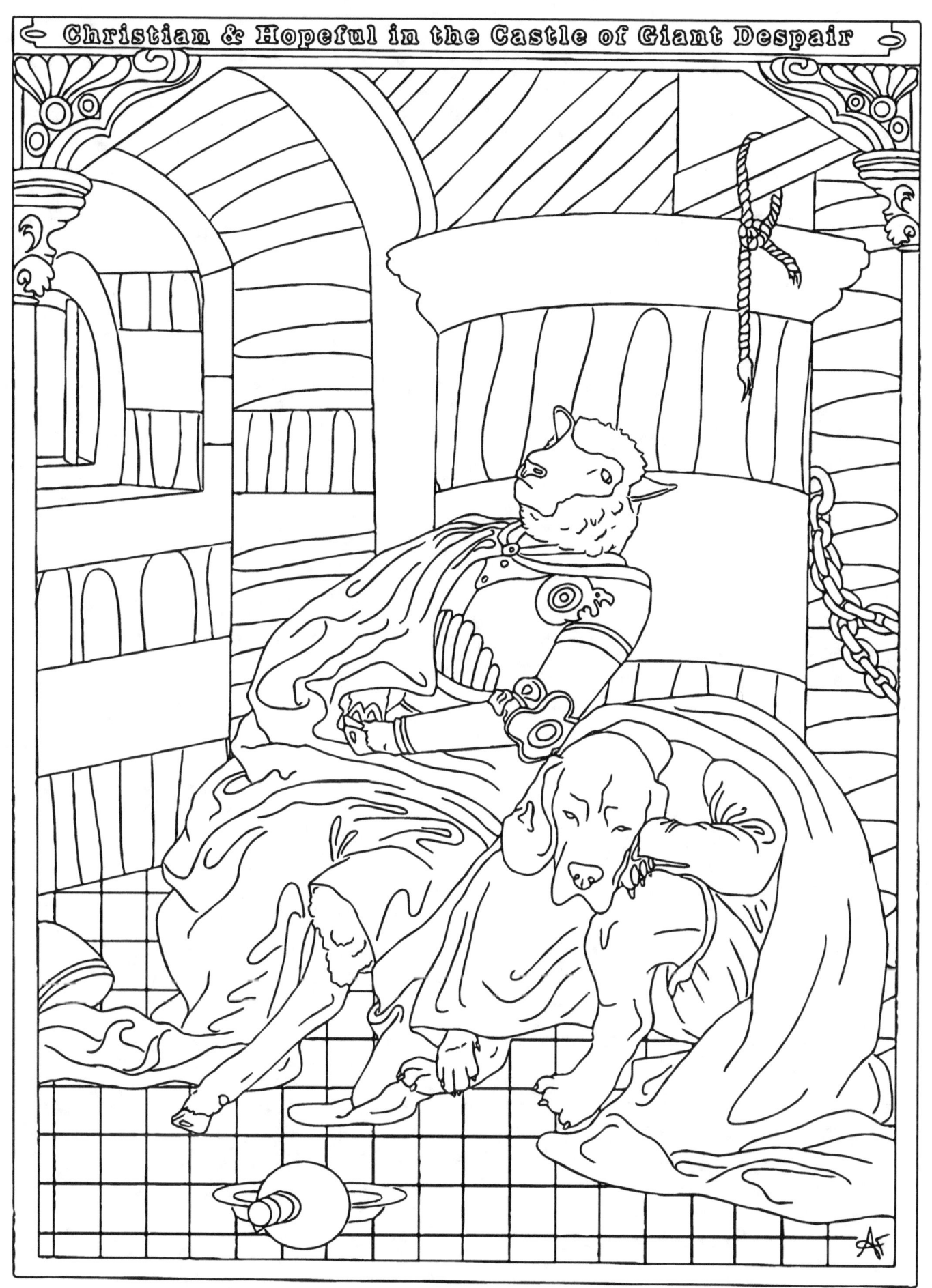

Castle of Giant Despair

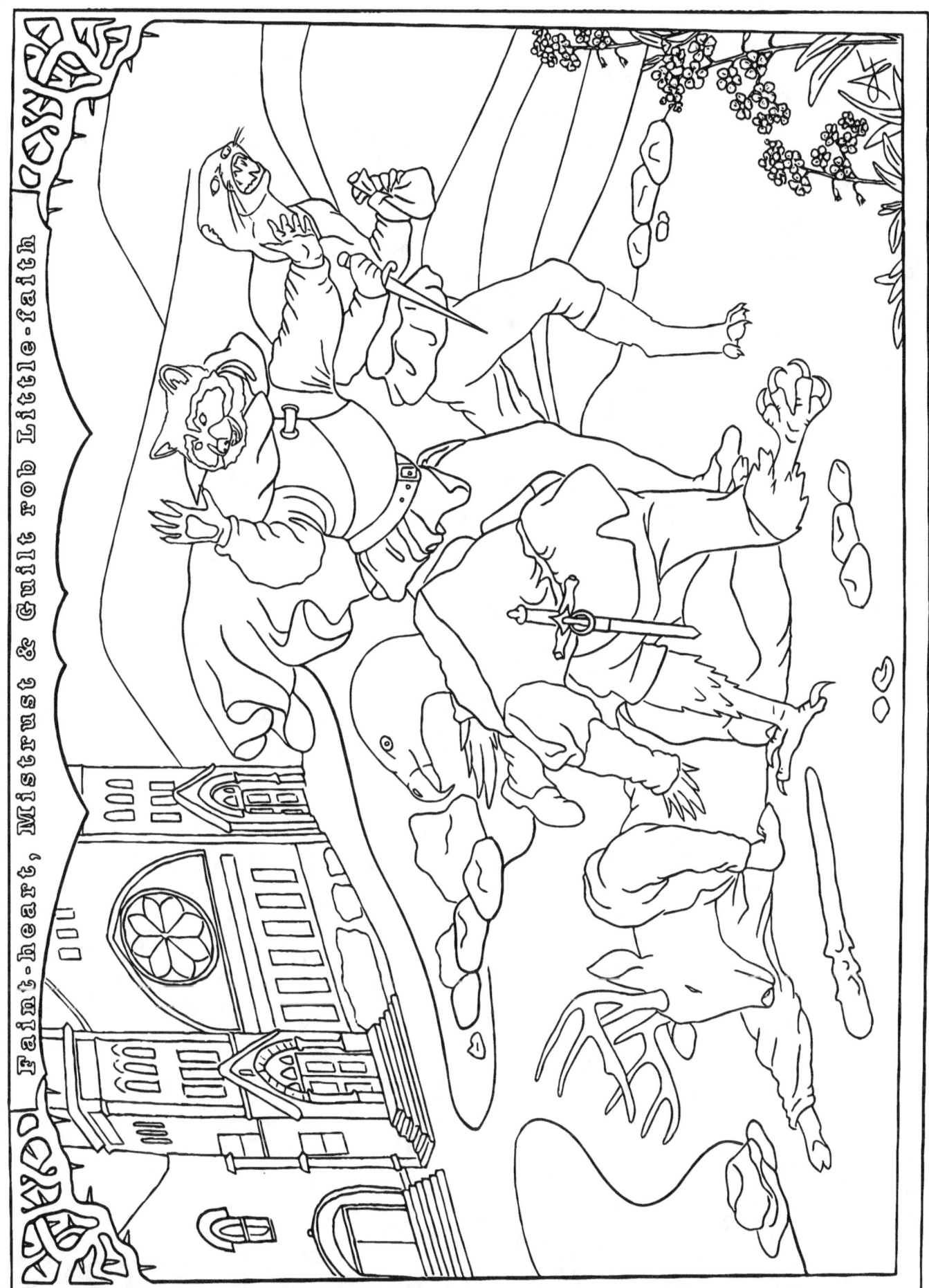

Little-faith robbed

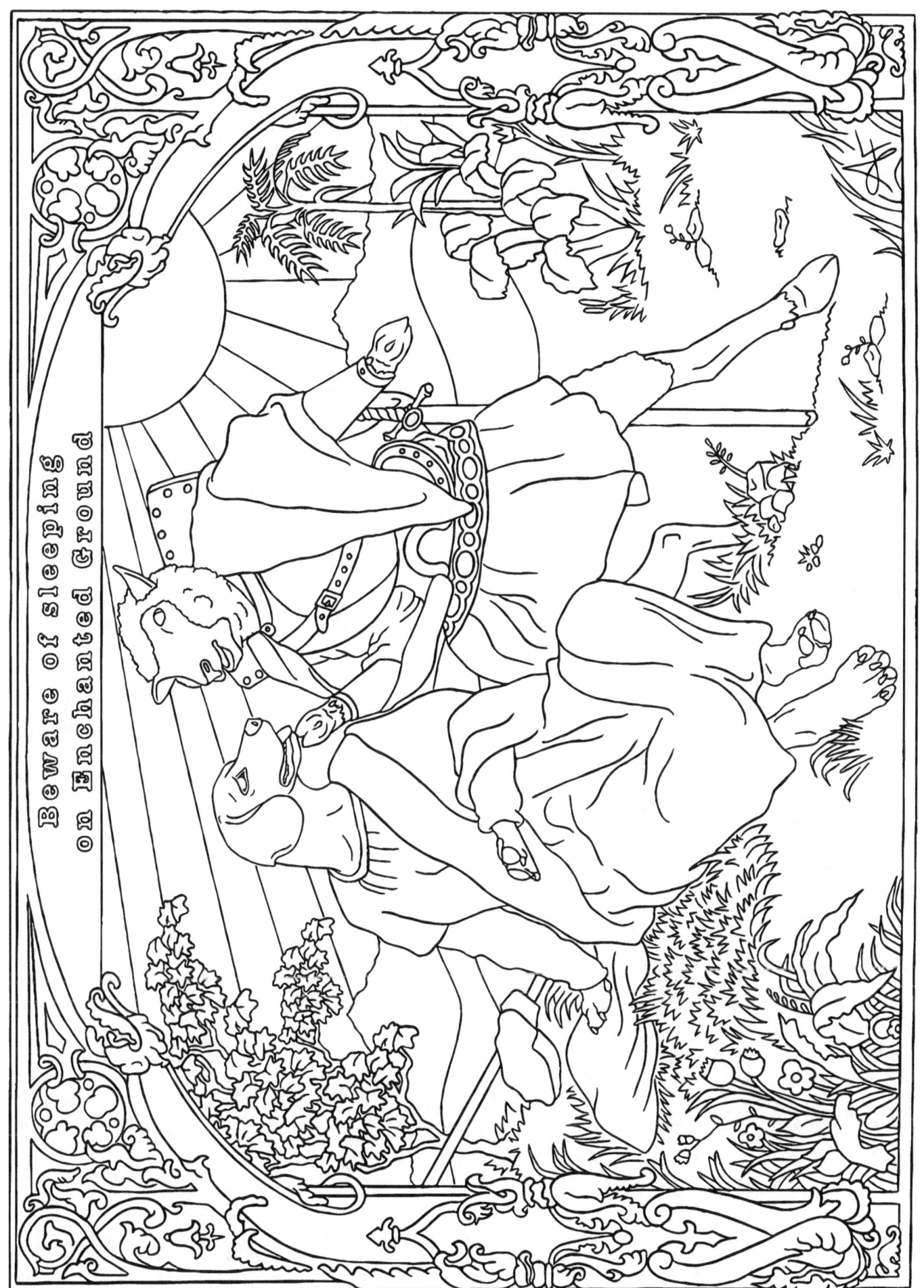

Enchanted Ground

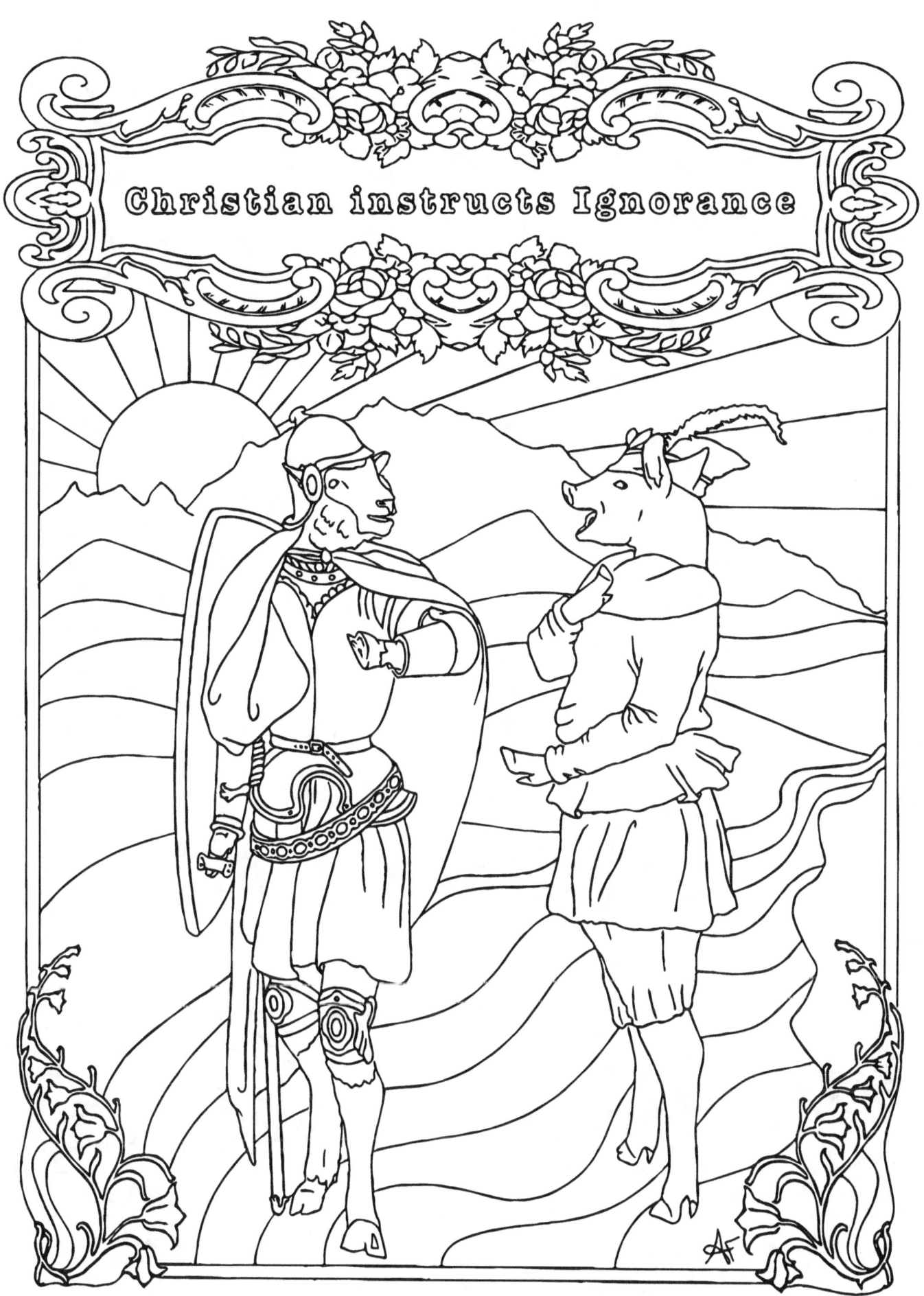

Christian instructs Ignorance

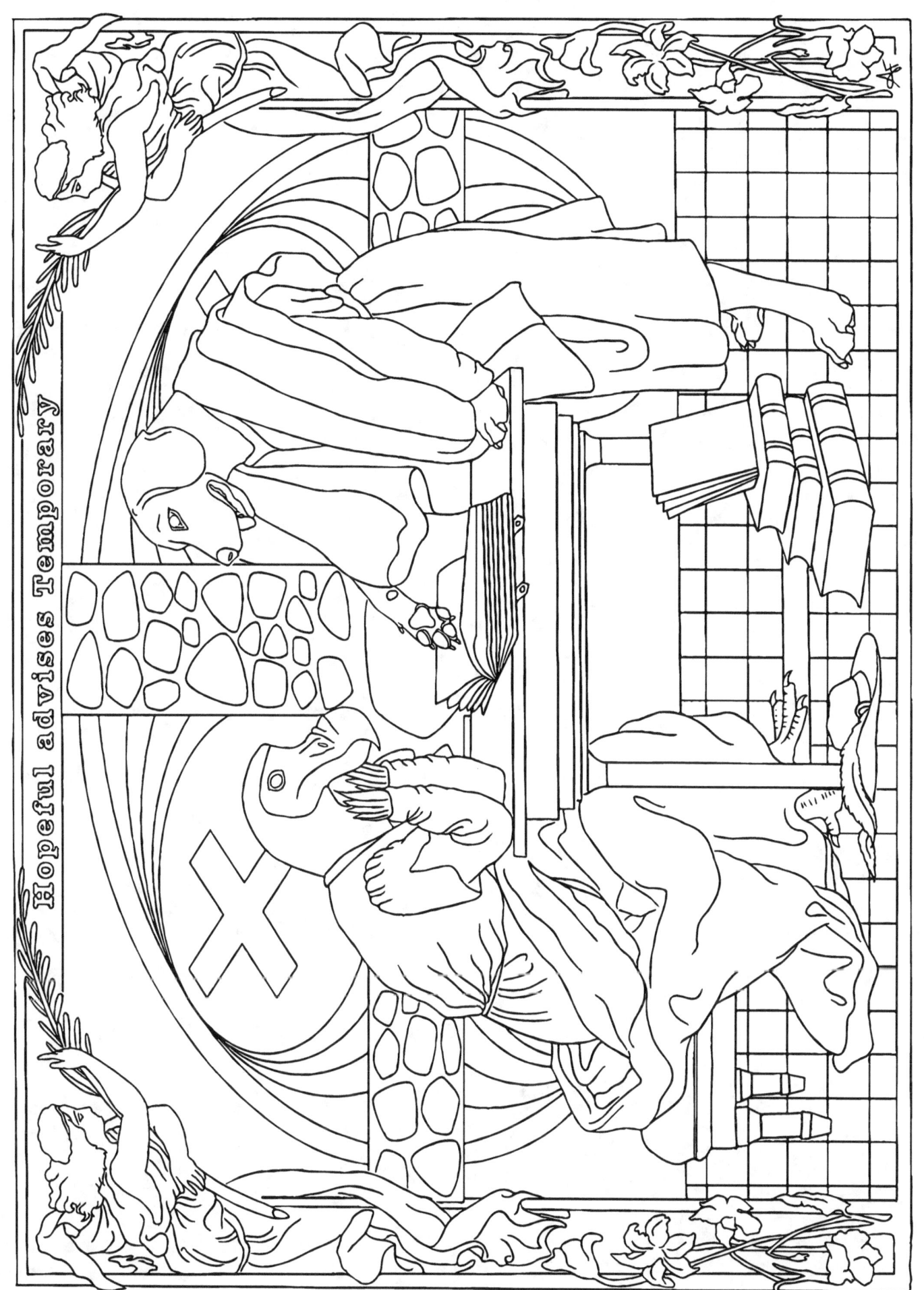

Hopeful advises Temporary

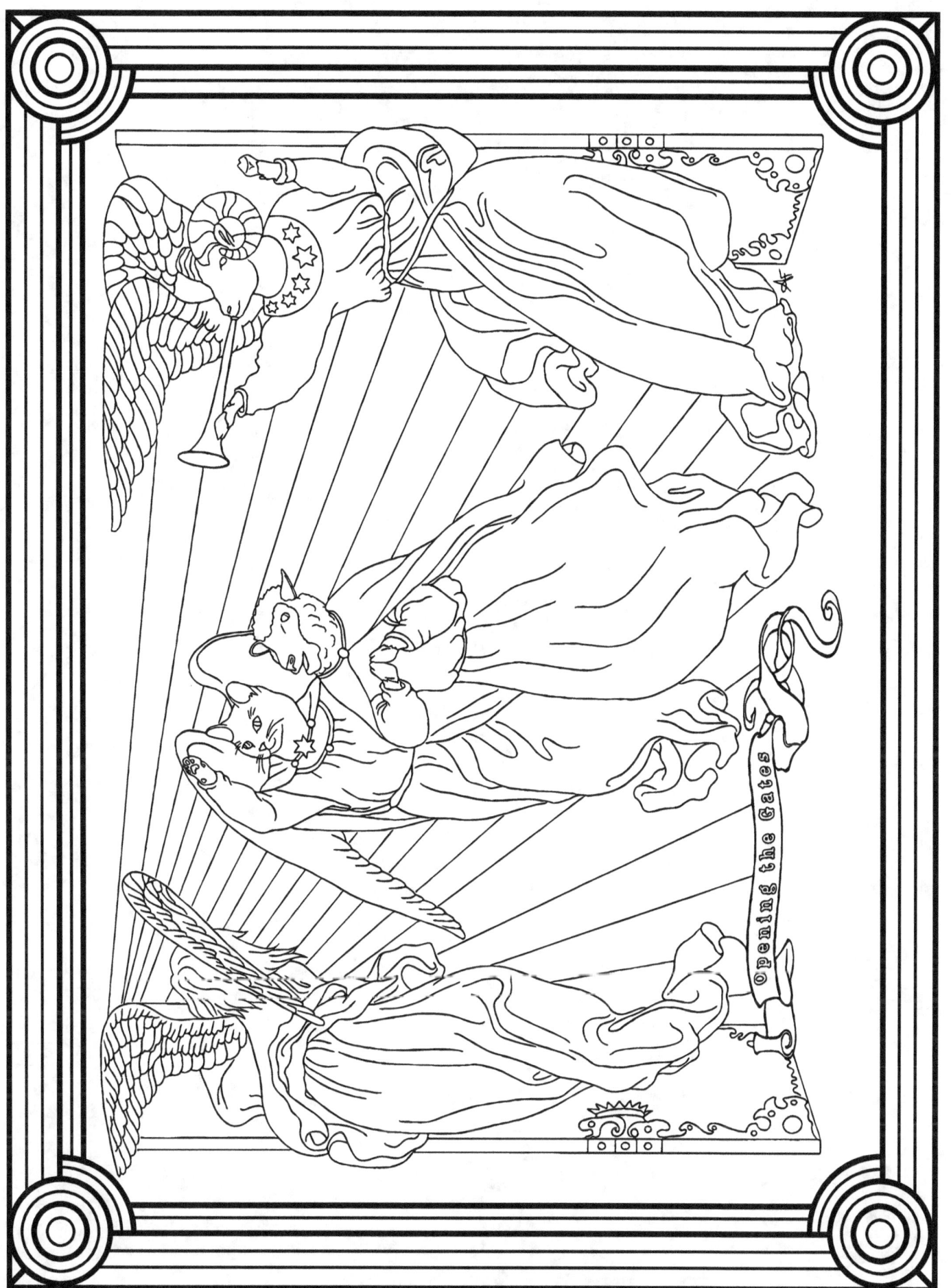

Entering the Celestial City

www.ingramcontent.com/pod-product-compliance
Lightning Source LLC
Chambersburg PA
CBHW081700220526

45466CB00009B/2827